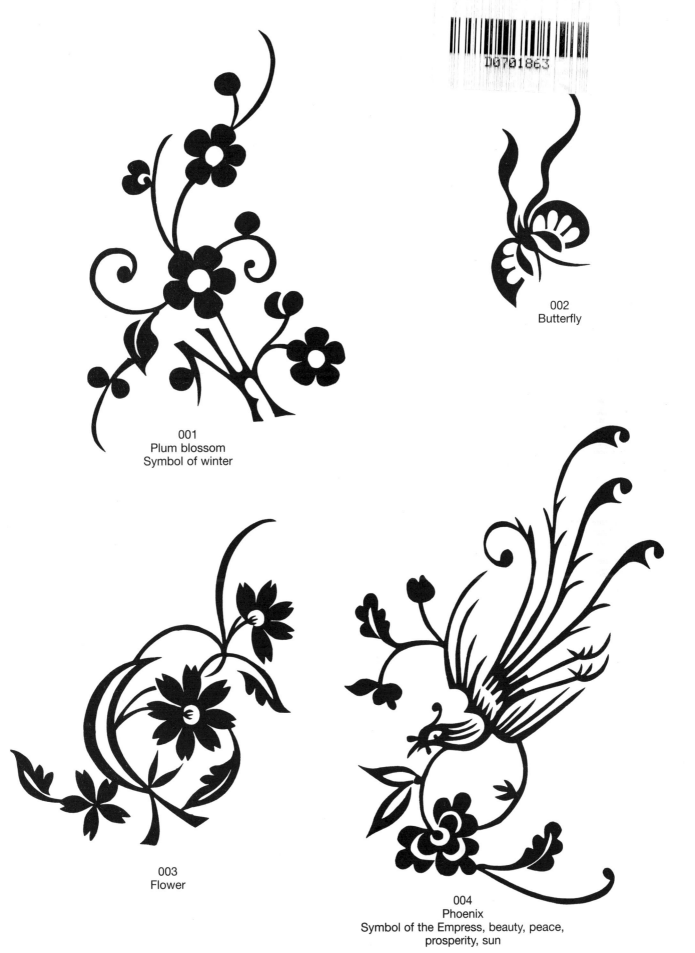

001
Plum blossom
Symbol of winter

002
Butterfly

003
Flower

004
Phoenix
Symbol of the Empress, beauty, peace,
prosperity, sun

005
Shou, coins, and bat
Symbol of long life, wealth,
and happiness

006
Flower

007
Boat

008
Lion playing with balls
Symbol of valor, power

009
Parrot

010
Sunrise

011
Butterfly

012
Bird

013
Dragons and pearl

014
Mandarin ducks

015
Hsi and butterfly
Symbol of joy

3

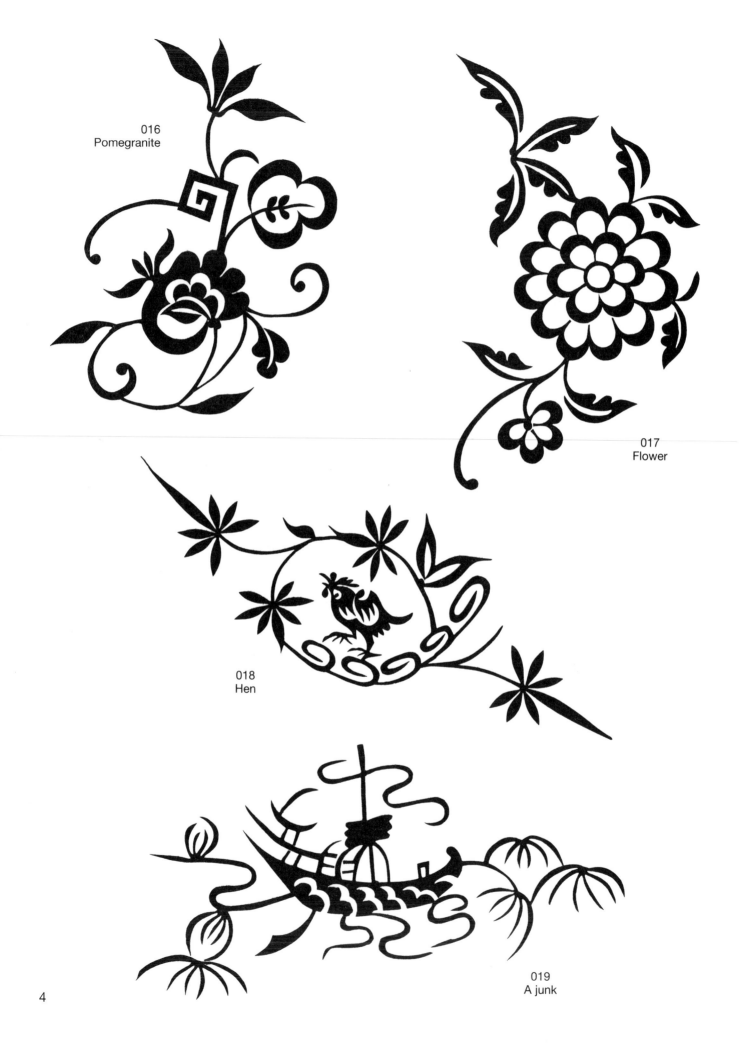

016
Pomegranite

017
Flower

018
Hen

019
A junk

4

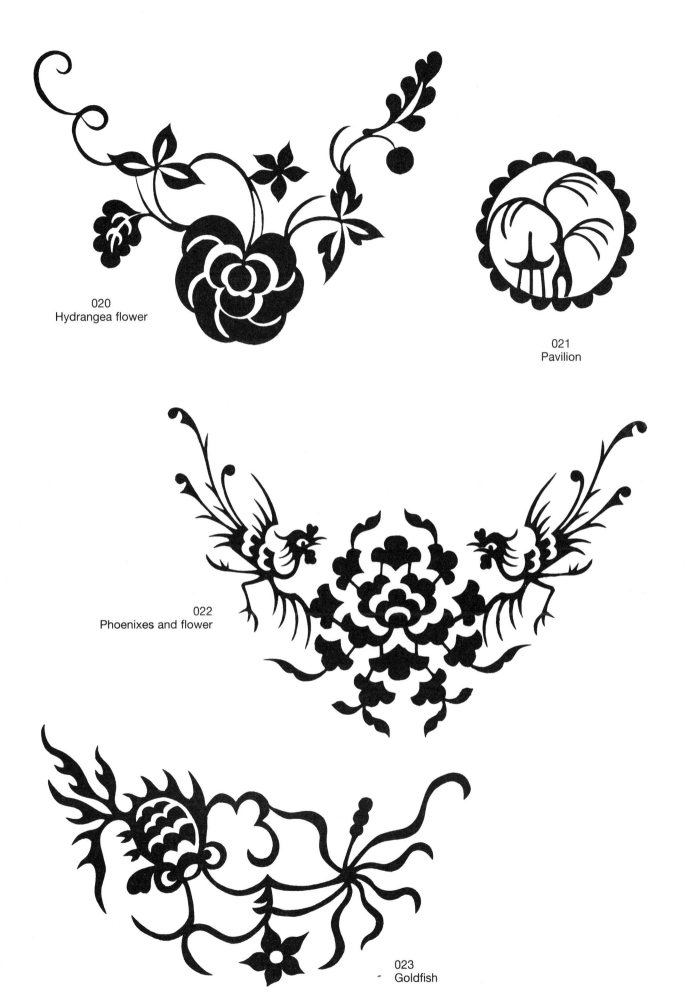

020
Hydrangea flower

021
Pavilion

022
Phoenixes and flower

023
Goldfish

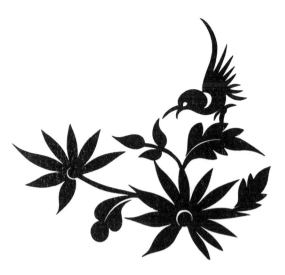

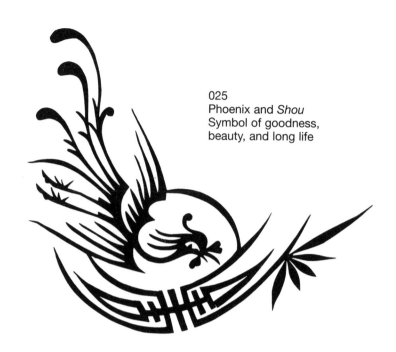

025
Phoenix and *Shou*
Symbol of goodness,
beauty, and long life

024
Bird and flower

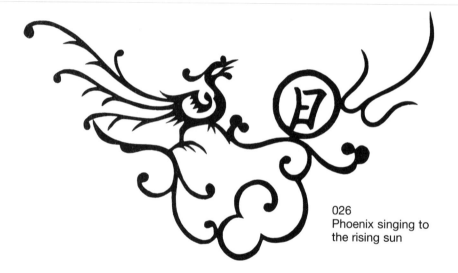

026
Phoenix singing to
the rising sun

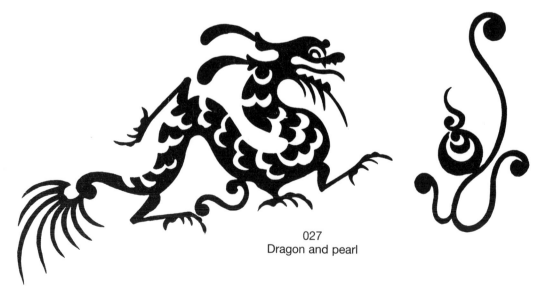

027
Dragon and pearl

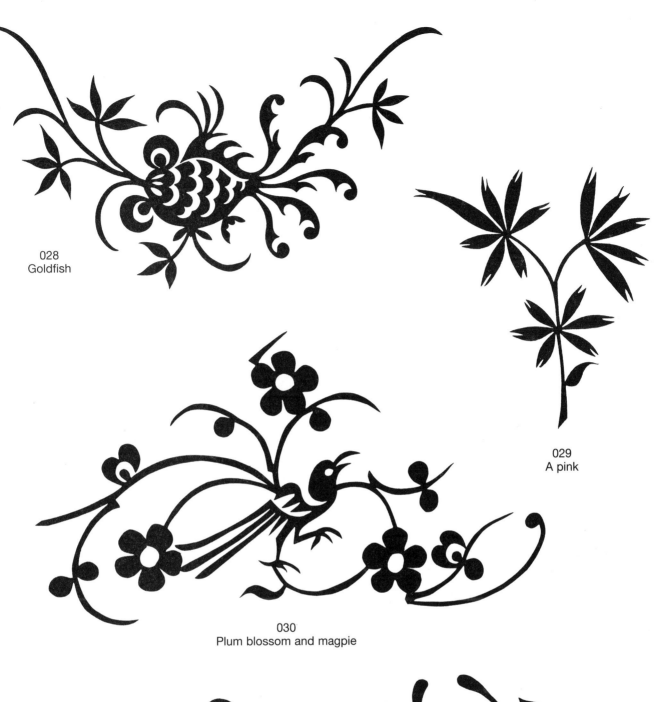

028
Goldfish

029
A pink

030
Plum blossom and magpie

031
Chrysanthemum

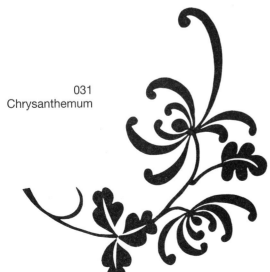

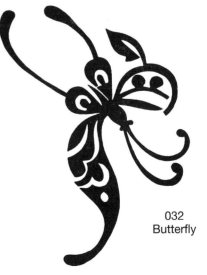

032
Butterfly

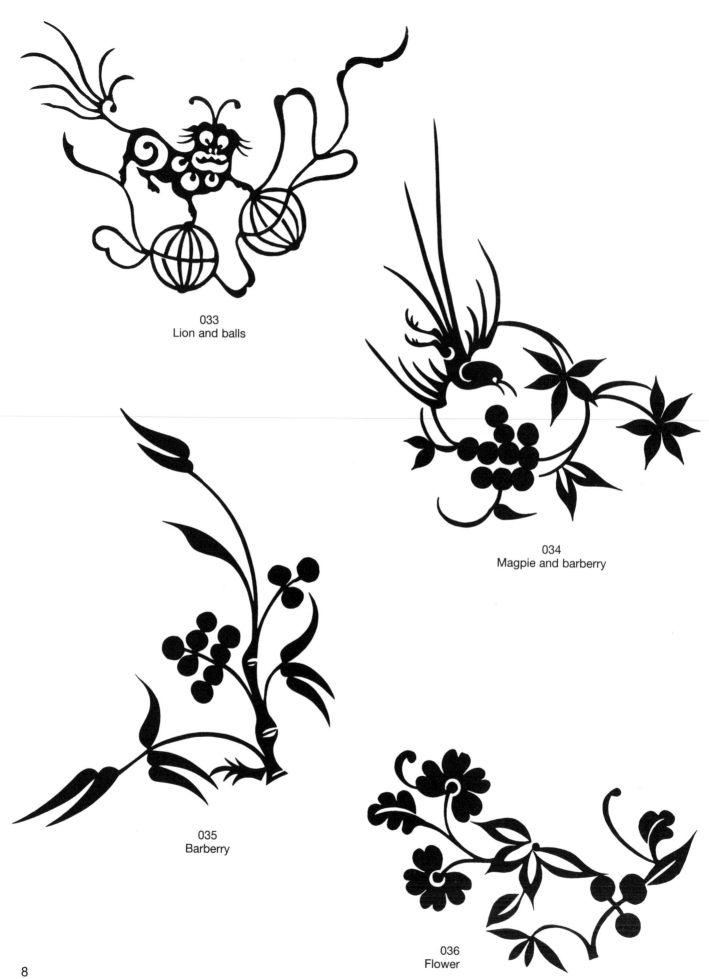

033
Lion and balls

034
Magpie and barberry

035
Barberry

036
Flower

8

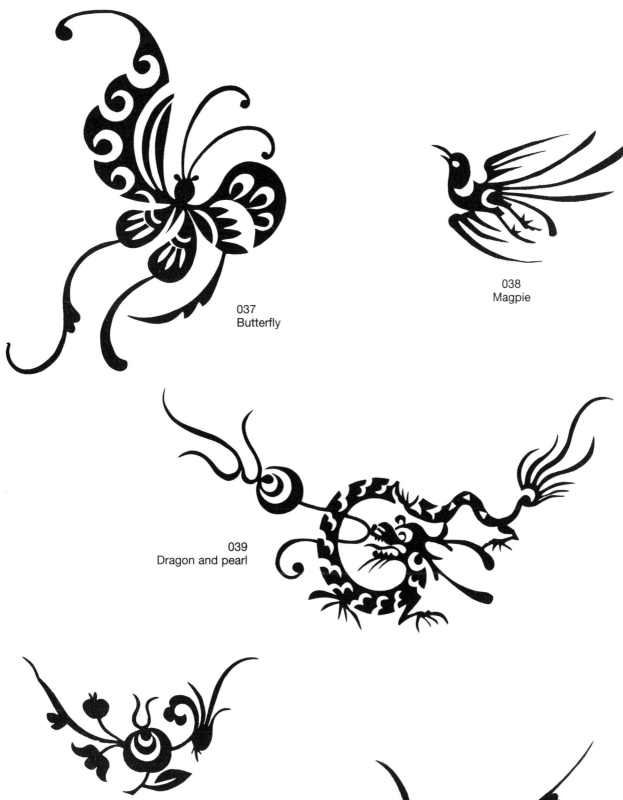

037
Butterfly

038
Magpie

039
Dragon and pearl

040
Sacred jewel
Symbol of beauty and purity

041
Symbol of
longevity and wealth

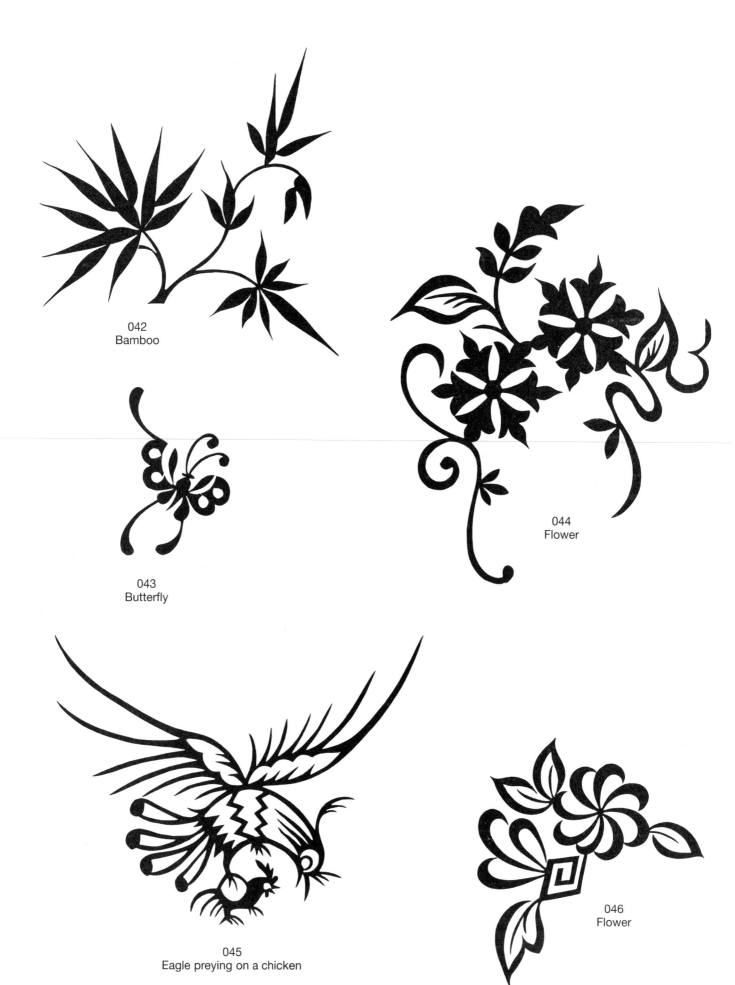

042
Bamboo

043
Butterfly

044
Flower

045
Eagle preying on a chicken

046
Flower

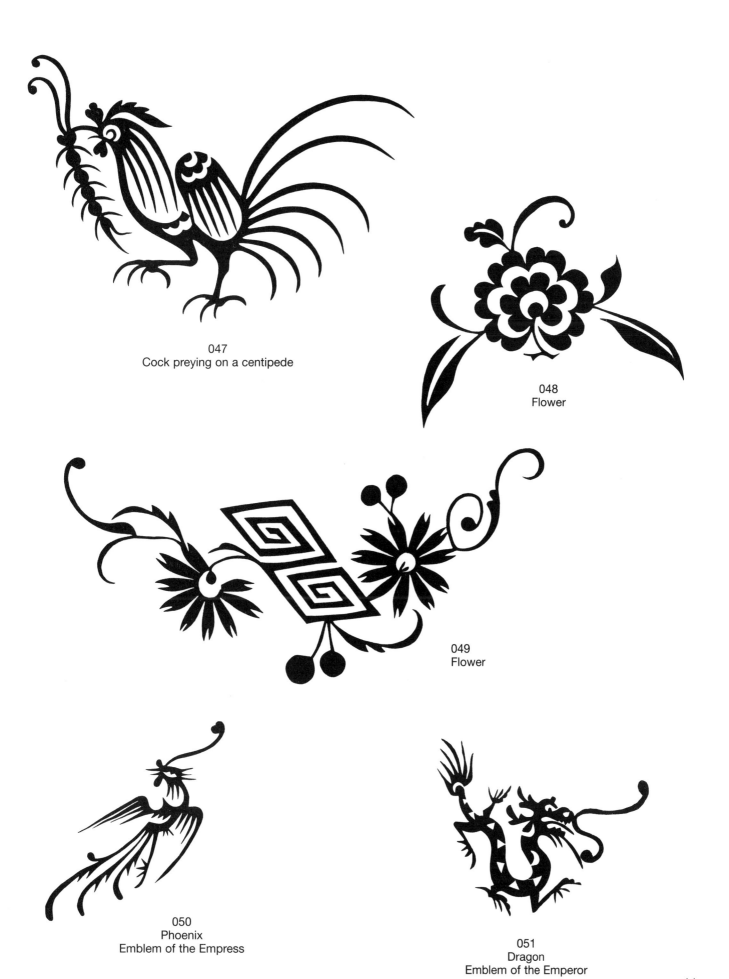

047
Cock preying on a centipede

048
Flower

049
Flower

050
Phoenix
Emblem of the Empress

051
Dragon
Emblem of the Emperor

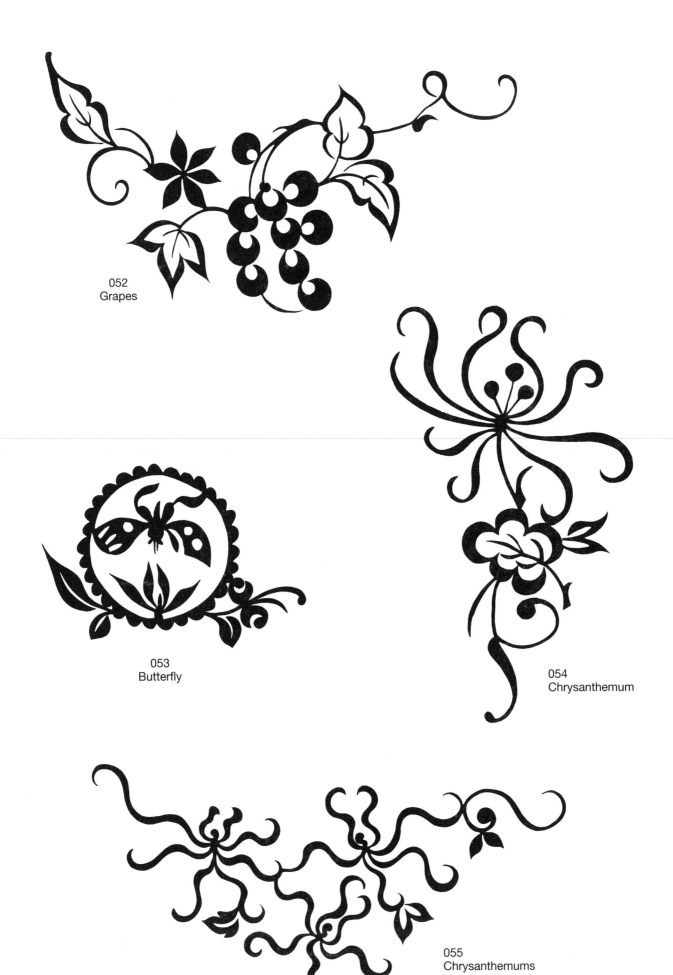

052
Grapes

053
Butterfly

054
Chrysanthemum

055
Chrysanthemums

056
Bird

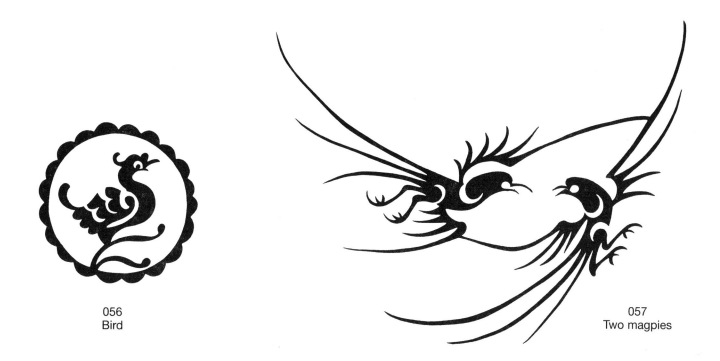

057
Two magpies

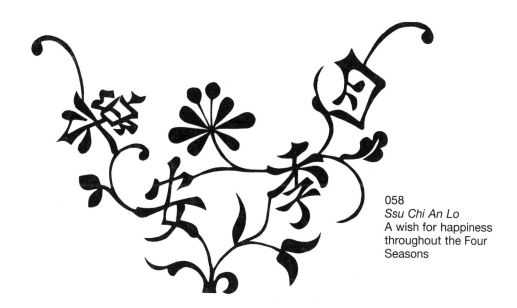

058
Ssu Chi An Lo
A wish for happiness
throughout the Four
Seasons

059
Boat

060
Flower

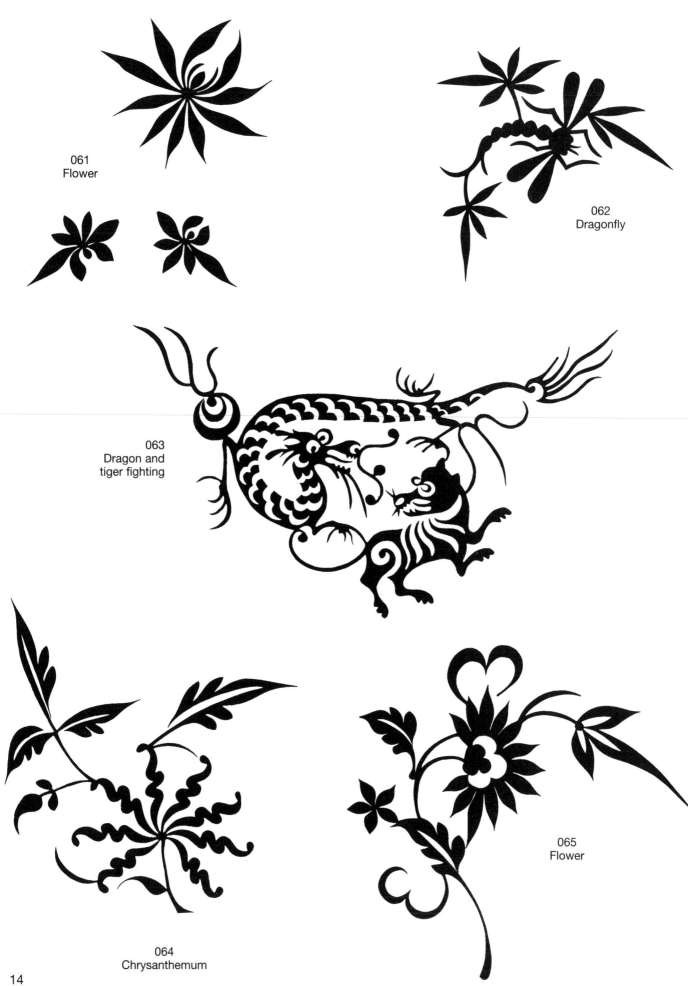

061
Flower

062
Dragonfly

063
Dragon and
tiger fighting

064
Chrysanthemum

065
Flower

066
Waterlily, bats, and coins
Symbol of purity, long life, and wealth

067
Crane

068
Three *Shou* characters
Symbol of long life

069
Flower

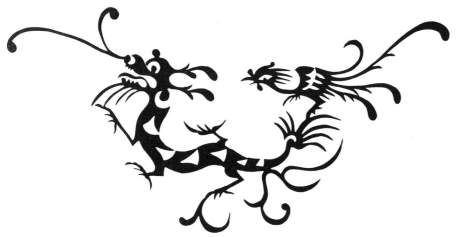

070
Dragon and phoenix

071
Citron

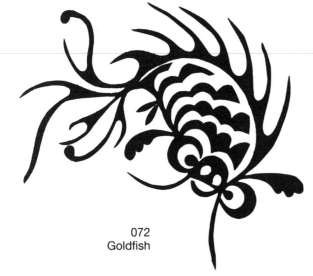

072
Goldfish

074
Flower

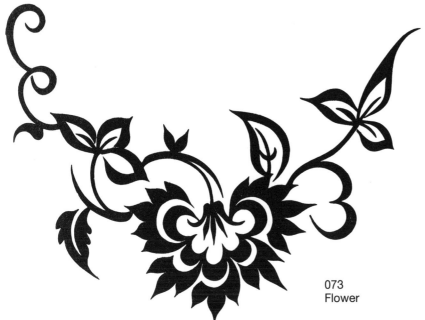

073
Flower

075
Two cranes

076
Shou, bats, and coins
Symbol of longevity and
prosperity

077
Sheep

078
Mandarin ducks

079
Toad and coins
Symbol of wealth

081
Five venimous things: tiger, snake, lizard, centipede, and spider

080
Flower

082
Flower

083
Ch'u Men Chien Ts'ai
Venture forth if you would find your fortune

084
Snake devouring a frog

085
Flower

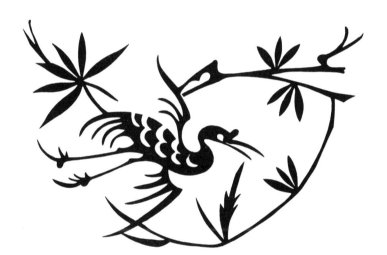

086
Crane

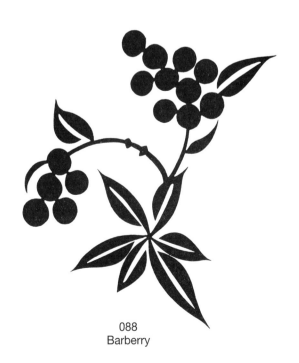

088
Barberry

087
Shou, bat, and butterfly
Symbol of long life and joy

089
Cat

090
Flower

091
Goose

092
Flower

093
Flower

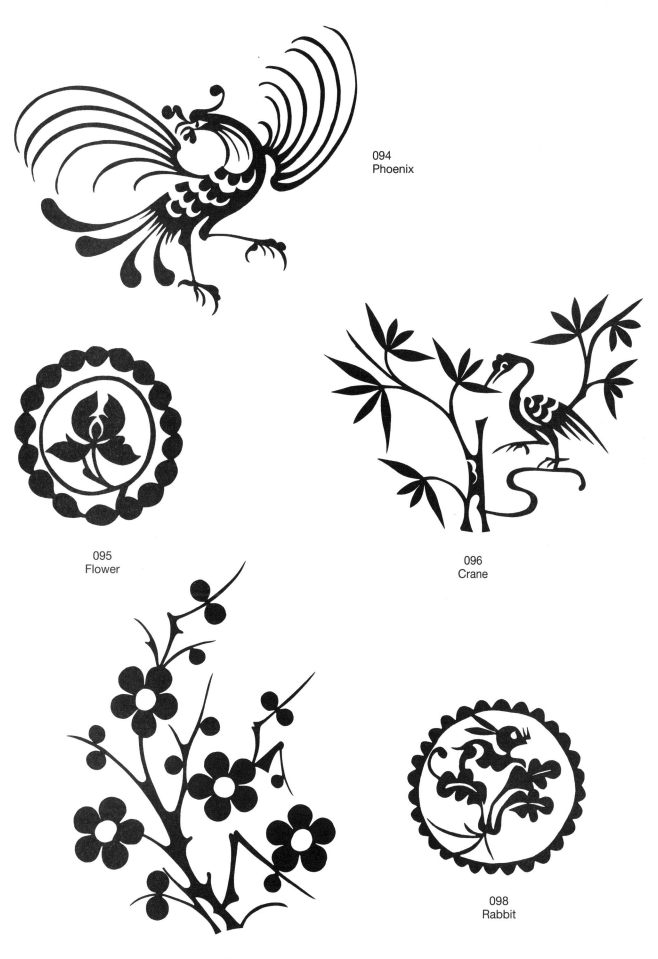

094
Phoenix

095
Flower

096
Crane

097
Plum blossom

098
Rabbit

21

099
Flower

100
Pheasant

101
Tiger

102
Falling flowers

103
Flower

104
Rabbit

105
Lark and chicken

106
Magpie

107
Flower

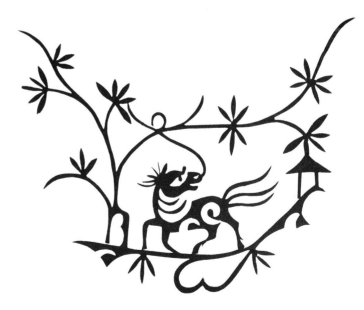

109
Horse

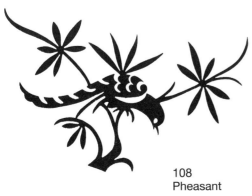

108
Pheasant

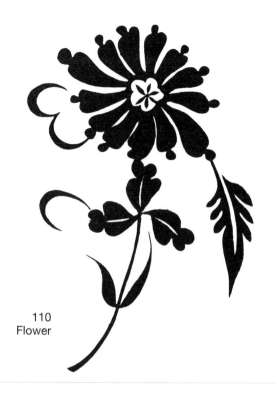

110
Flower

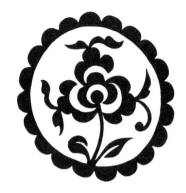

111
Flower

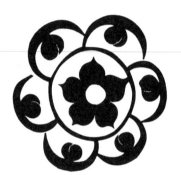

112
Flower

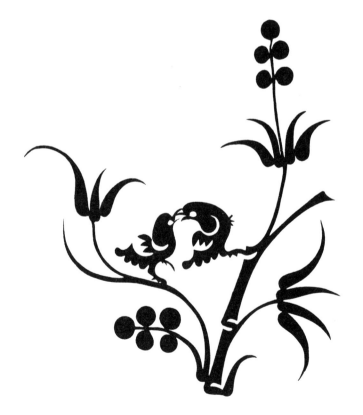

113
Birds kissing

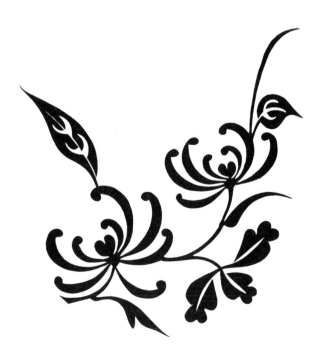

114
Chrysanthemum

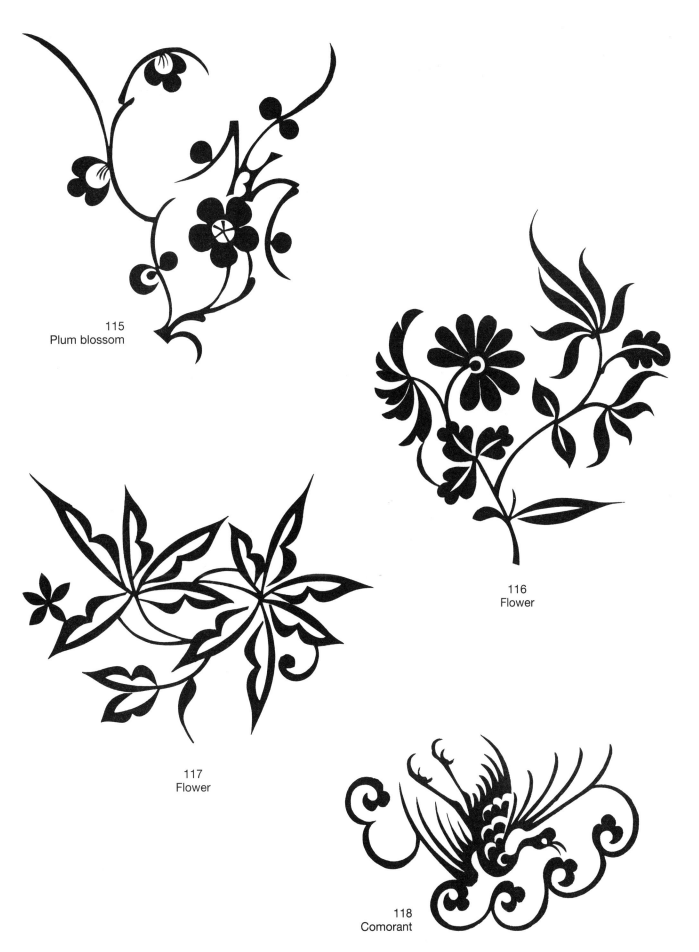

115
Plum blossom

116
Flower

117
Flower

118
Comorant

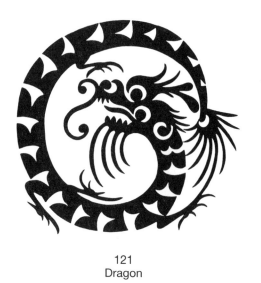

119
Bat

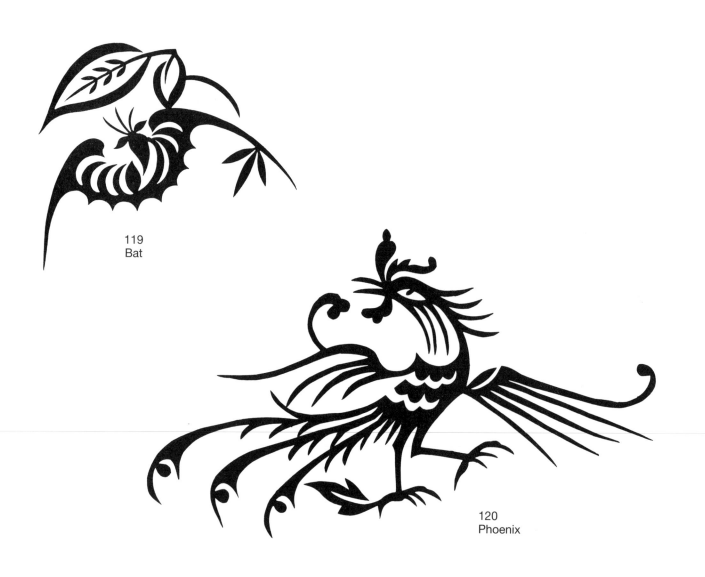

120
Phoenix

121
Dragon

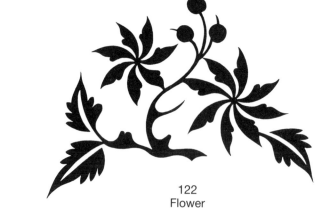

122
Flower

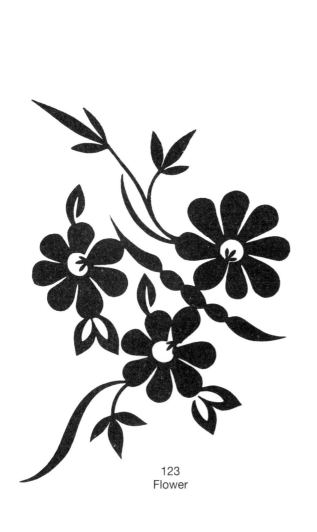

123
Flower

124
Chrysanthemum

125
Wasp

126
Phoenix

127
Flower

128
Flower

129
Clouds

130
Landscape

131
Boat

132
Dragon

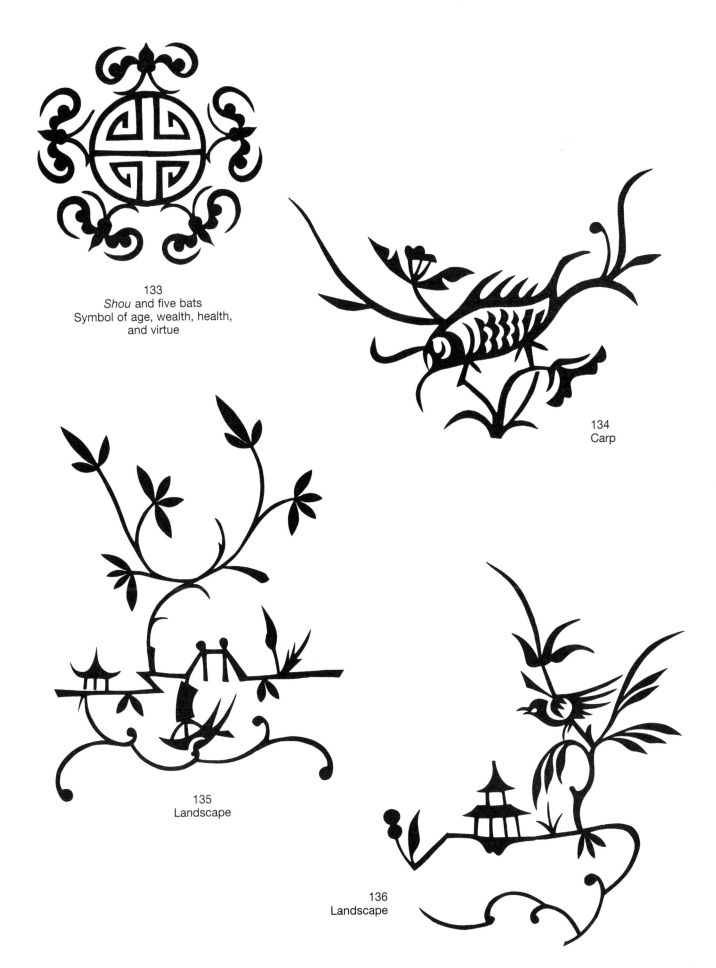

133
Shou and five bats
Symbol of age, wealth, health,
and virtue

134
Carp

135
Landscape

136
Landscape

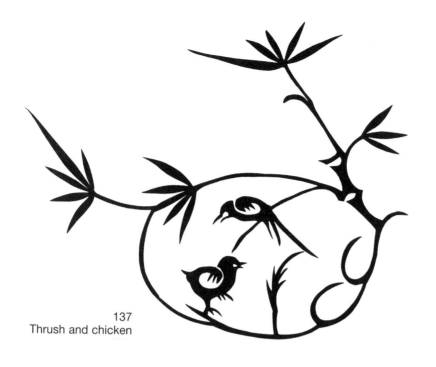

137
Thrush and chicken

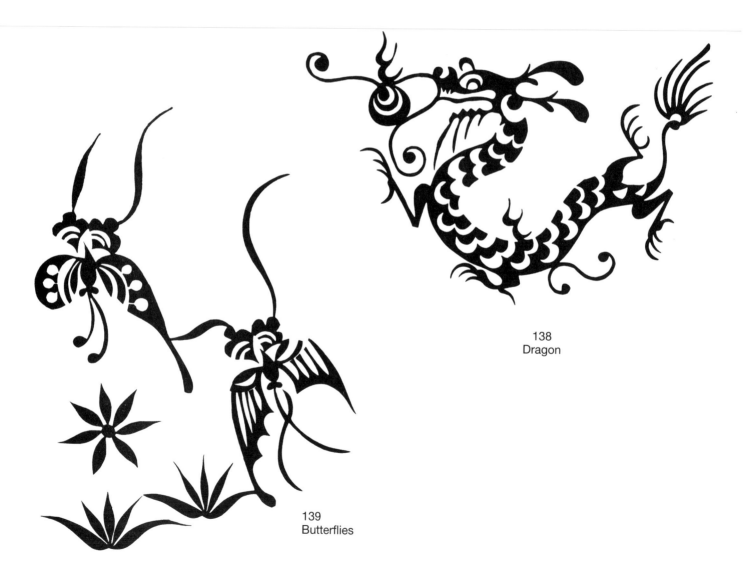

138
Dragon

139
Butterflies

140
Moon and stars

141
Landscape

142
Landscape

143
Dragonflies

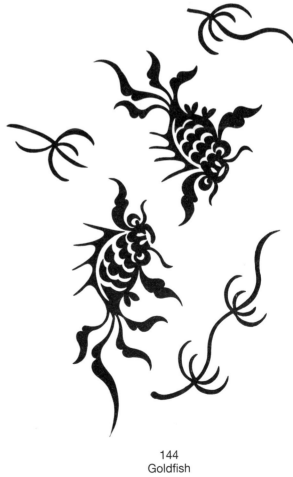

144
Goldfish

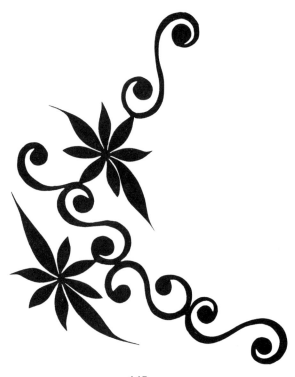

145
Flower

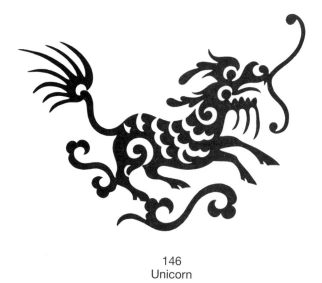

146
Unicorn

147
Shrimp

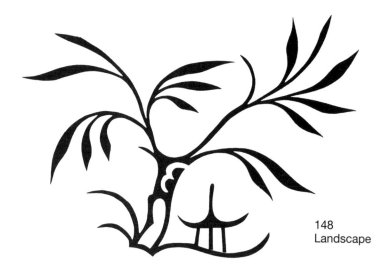

148
Landscape

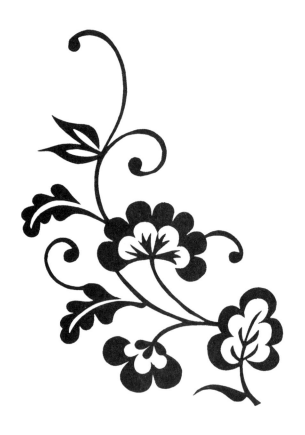

149
Flower

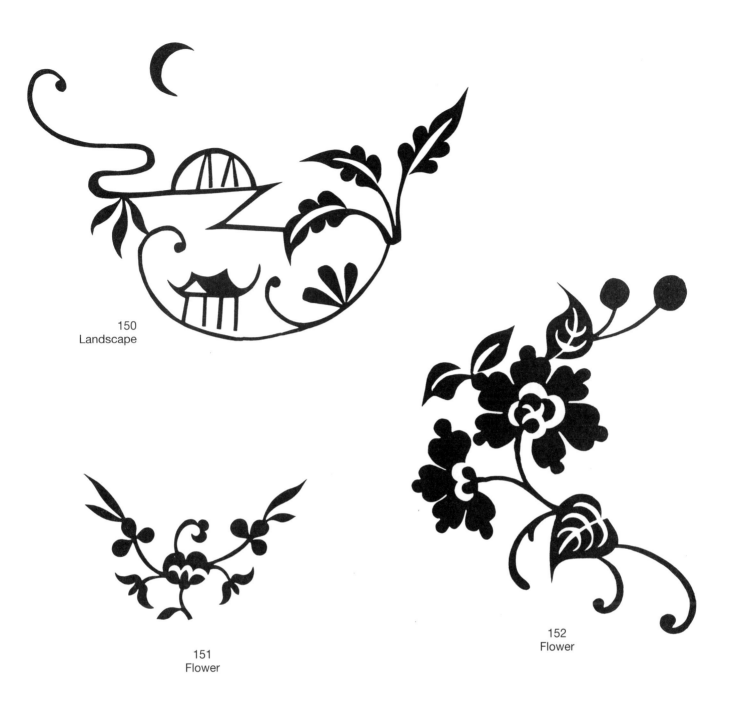

150
Landscape

151
Flower

152
Flower

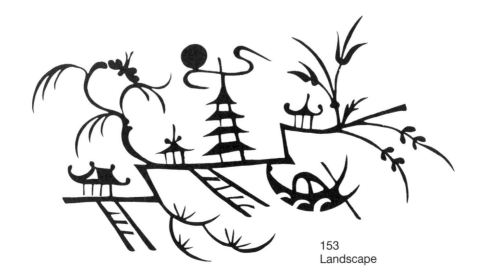

153
Landscape

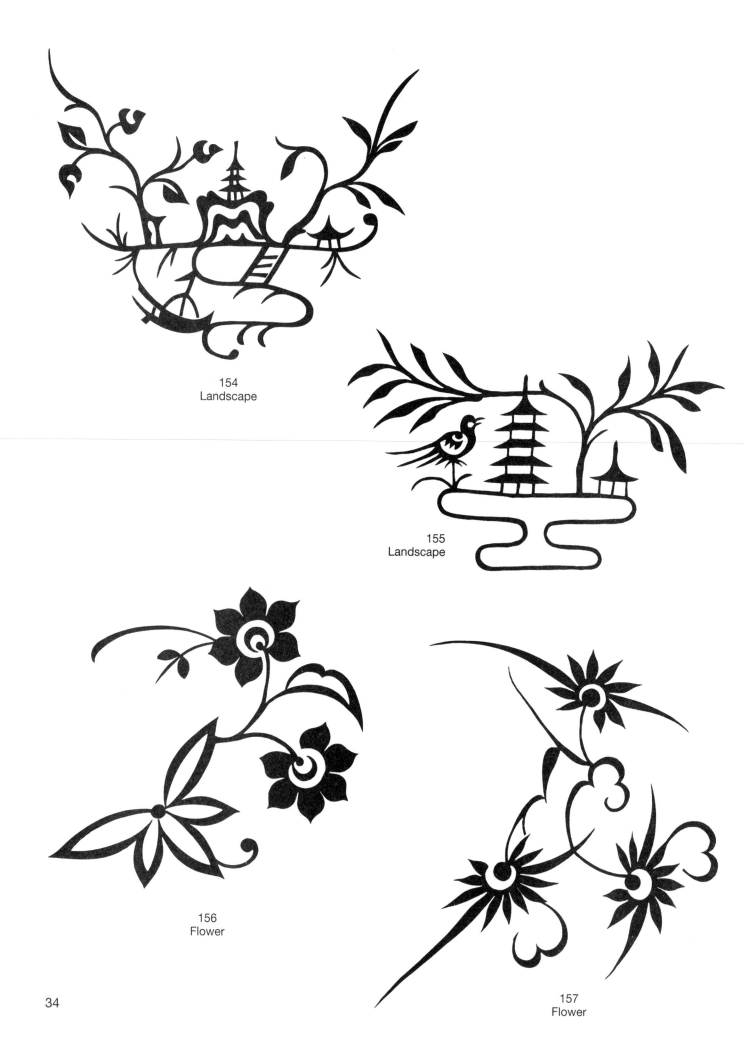

154
Landscape

155
Landscape

156
Flower

157
Flower

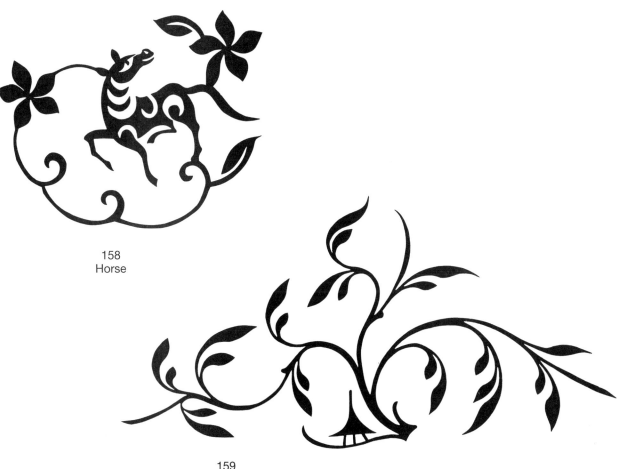

158
Horse

159
Landscape

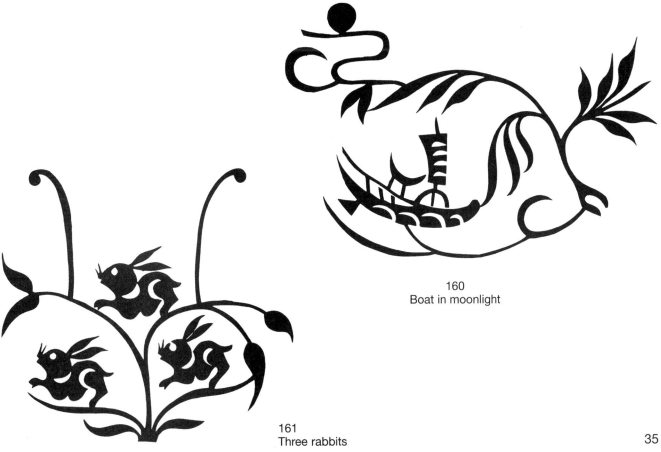

160
Boat in moonlight

161
Three rabbits

35

162
Shou
Symbol of longevity

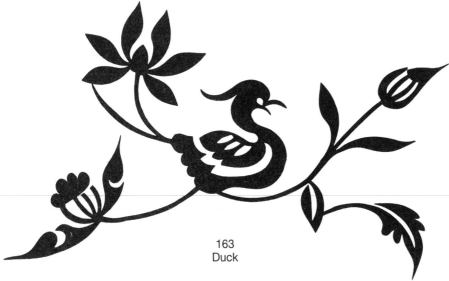
163
Duck

164
Flower

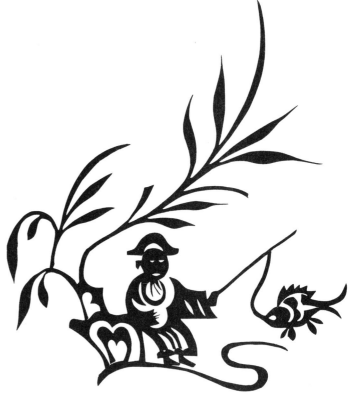
165
Chiang T'ai-kung fishing in the
Wei River

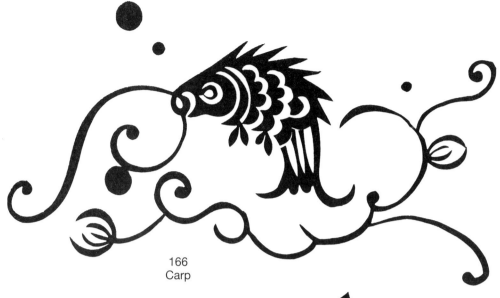

166
Carp

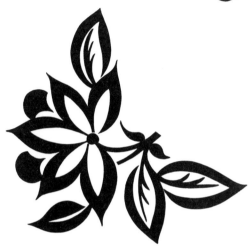

167
Flower

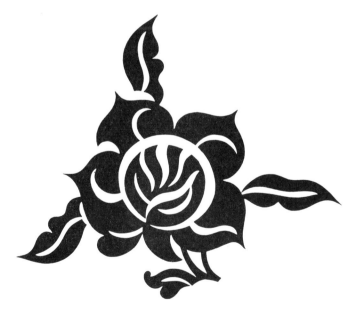

168
Flower

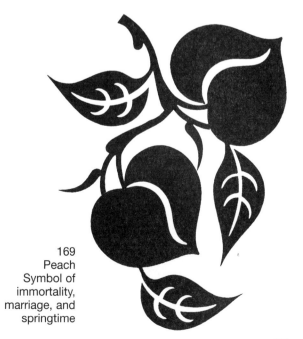

169
Peach
Symbol of
immortality,
marriage, and
springtime

170
Barberry

171
Chinese persimmon

172
Flower

173
Lotus

174
Bamboo

175
Dragonfly

176
Carp leaping
through the
Dragon Gate

177
Flower

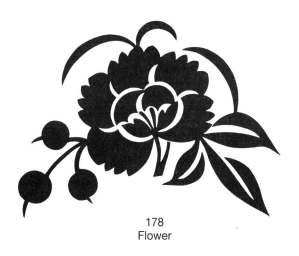

178
Flower

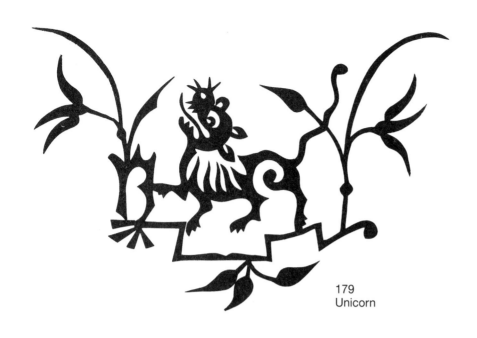

179
Unicorn

180
Citron and bat

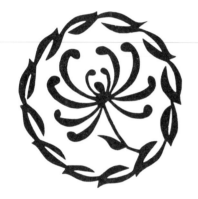

181
Chrysanthemum

182
Mallow

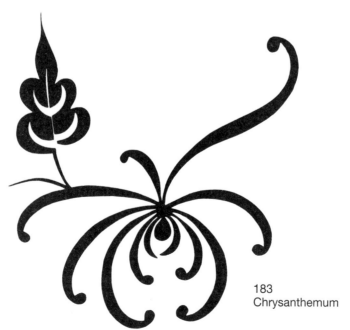

183
Chrysanthemum

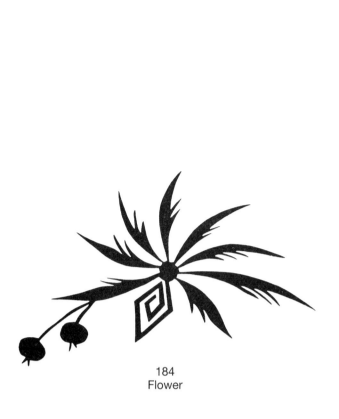

184
Flower

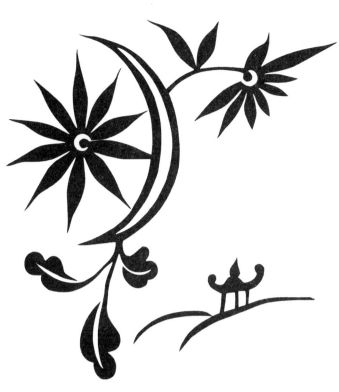

185
New moon

186
Flower

187
Flower

188
Flower

189
Dog and lotus

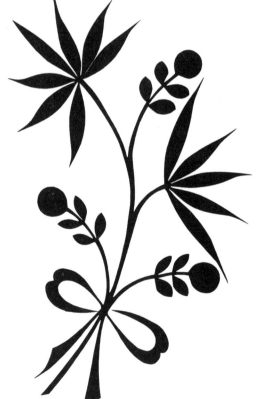

190
Flower

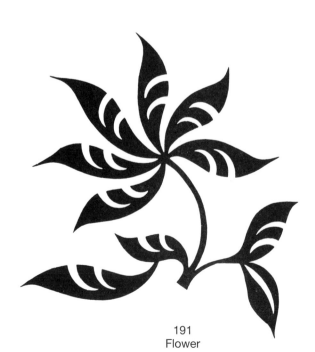

191
Flower

192
Chao Ts'ai Chin Pao
A charm to bring wealth

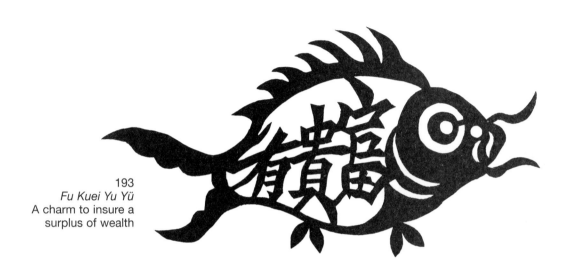

193
Fu Kuei Yu Yü
A charm to insure a
surplus of wealth

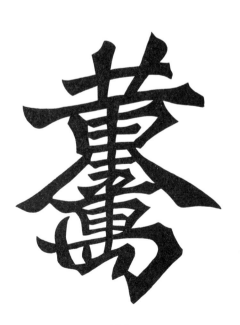

194
Huang Chin Wan Liang
A charm to bring 10,000 ounces of gold

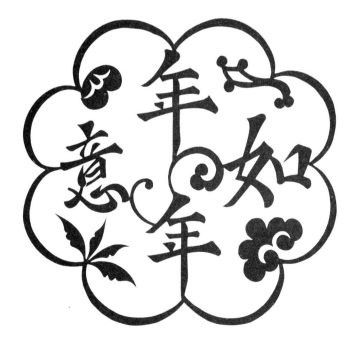

195
Nien Nien Ju I
A charm to provide satisfaction
year by year

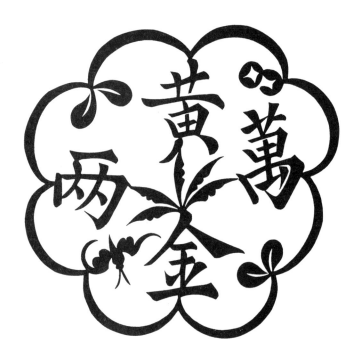

196
Huang Chin Wan Liang
A charm to bring 10,000
ounces of gold

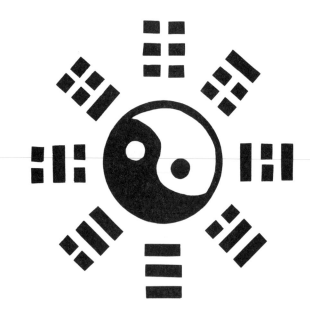

197
Yang Yin and *Pa Kua* symbols

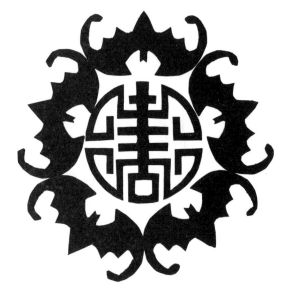

198
Shou and five bats
Symbol of longevity, wealth, and virtue

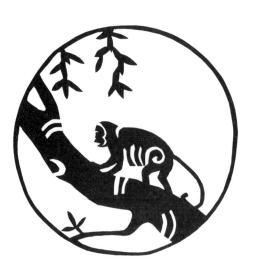

199
Monkey

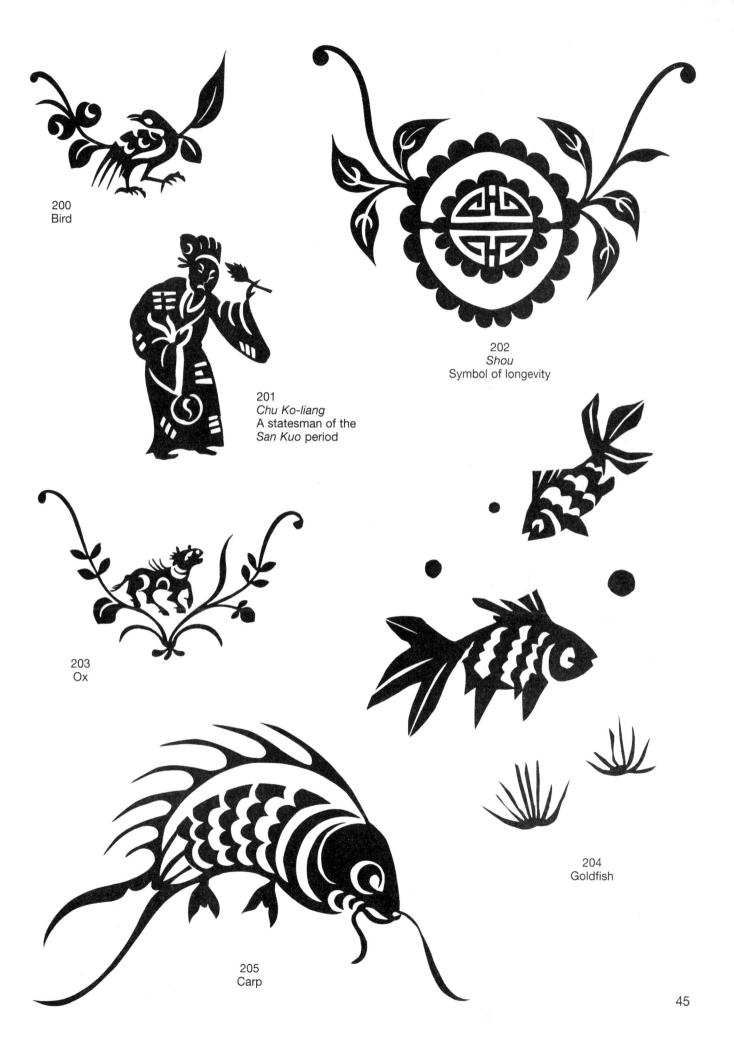

200
Bird

201
Chu Ko-liang
A statesman of the
San Kuo period

202
Shou
Symbol of longevity

203
Ox

204
Goldfish

205
Carp

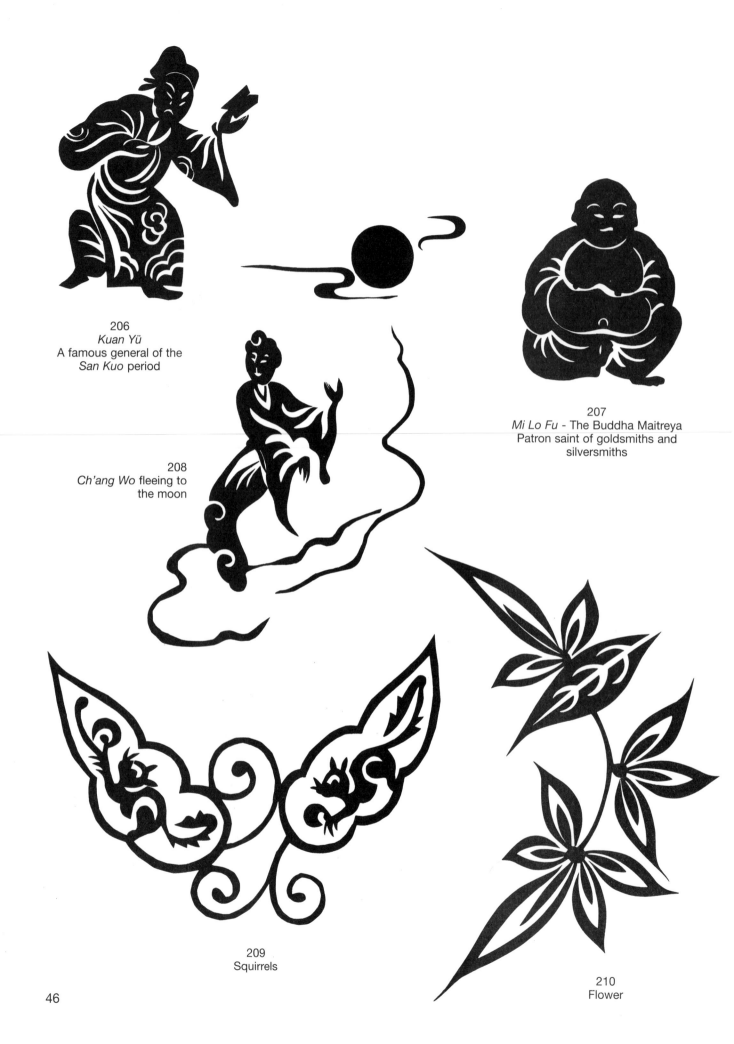

206
Kuan Yü
A famous general of the
San Kuo period

207
Mi Lo Fu - The Buddha Maitreya
Patron saint of goldsmiths and
silversmiths

208
Ch'ang Wo fleeing to
the moon

209
Squirrels

210
Flower

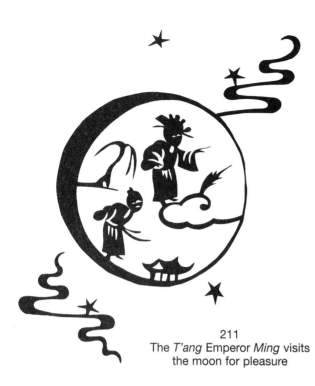

211
The *T'ang* Emperor *Ming* visits
the moon for pleasure

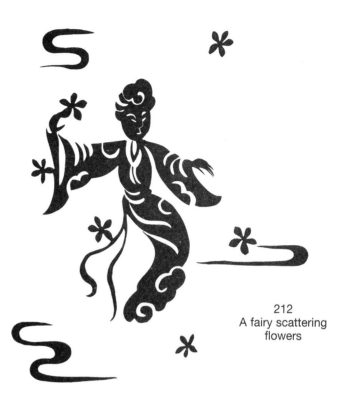

212
A fairy scattering
flowers

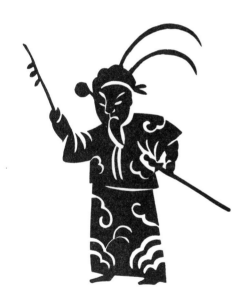

213
Yang Ssu-lang visits his
mother

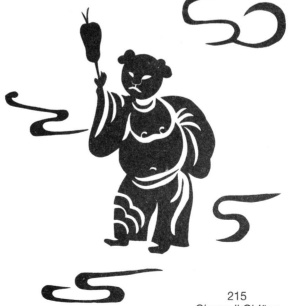

215
Chung-li Ch'üan
Chief of the Eight Immortals

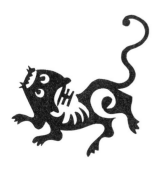

214
Tiger
Symbol of bravery

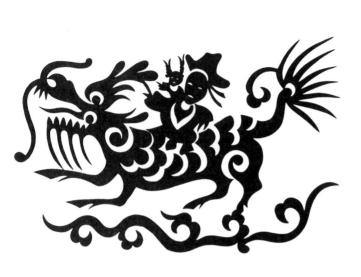

216
Unicorn carrying a boy child
A charm to insure male offspring

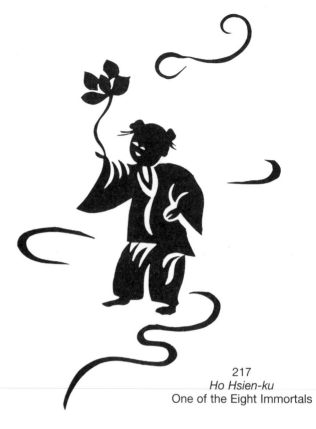

217
Ho Hsien-ku
One of the Eight Immortals

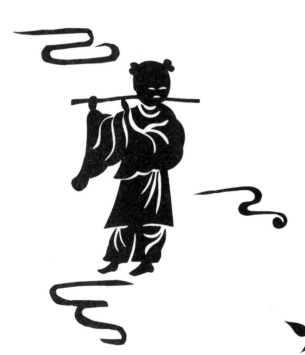

218
Han Hsiang-tzu
One of the Eight Immortals
Patron saint of musicians

219
Shou
Symbol of
longevity

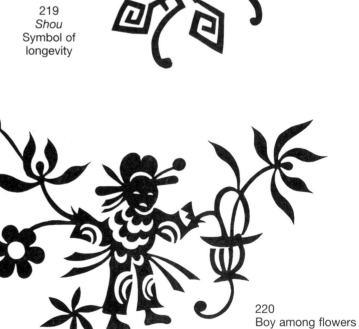

220
Boy among flowers